Mindful Eye, Playful Eye

101 Amazing Museum Activities for Discovery, Connection, and Insight

Michael Garbutt Nico Roenpagel Frank Feltens

Smithsonian Books
Washington, DC

Published by Smithsonian Books
Director: Carolyn Gleason
Senior Editor: Jaime Schwender
Editor: Julie Huggins

Edited by Sharon Silva
Designed by Daisuke Yajima
Typeset by Brian Barth

This book may be purchased for educational, business, or sales promotional use. For information, please write: Special Markets Department, Smithsonian Books, P.O. Box 37012, MRC 513, Washington, DC 20013

Printed in China, not at government expense
28 27 26 25 24 1 2 3 4 5

Library of Congress Cataloging-in-Publication Data

Names: Garbutt, Michael (Michael David), author. | Roenpagel, Nico, author. | Feltens, Frank, author.
Title: Mindful eye, playful eye : 101 amazing museum activities for discovery, connection, and insight / Michael Garbutt, Nico Roenpagel, Frank Feltens.
Description: Washington, DC : Smithsonian Books, 2024.
Identifiers: LCCN 2023031719 | ISBN 9781588347626 (trade paperback)
Subjects: LCSH: Art appreciation—Problems, exercises, etc. | Mindfulness (Psychology)—Problems, exercises, etc.
Classification: LCC N7477 .G35 2024 | DDC 708—dc23/eng/20230807
LC record available at https://lccn.loc.gov/2023031719

In and Beyond the Museum

The practices in *Mindful Eye, Playful Eye* belong to the growing number of innovative visitor-centered activities that now complement the traditional methods museum curators and educators use to engage audiences and inform them about their collections. Drawing on influences from drama theater games, mindfulness-based activities, art school exercises, and psychotherapeutic techniques, the 101 practices in this book invite visitors to curate their own personal museum experience. By attending to sensory sensations, witnessing feelings and thoughts, letting imagination run free, and experimenting with new ways of seeing and being, we can disrupt the habits and conventions that constrain museum encounters.

It's very simple. You just play, which means revel for its own sake in the hidden opportunities that can be found in every object and situation. Children instinctively know how to do this. Babies can find possibilities for play in their fingers and toes, older children in a stick or piece of string. From infancy, play is central to children's experience and essential for their healthy development. Through play, they explore their own minds and bodies, discover the world around them, and imagine other worlds. In playing with their peers, they learn to cooperate and compete. Throughout our lives, play remains a wellspring of creativity and delight. But many of us come to think of play as incompatible with the serious business of adulthood, viewing it as just the counterpart of work and rest, not the creative spark that can valorize every moment

of existence. Along with pioneering art museum educator Elliott Kai-Kee and his colleagues at the J. Paul Getty Museum, we share the conviction that, regardless of age, play is a powerful means of inquiry and a key to discovery, connection, and insight.

By discovery, we mean self-discovery, the discovery of exhibits, and perhaps also the discovery of other visitors. In the process of play, with ourselves or others, human or otherwise, we may connect with feelings of wonder and joy but also sorrow, fear, and anger. In either case, this connection can be a gift, an opportunity to uncover and then cradle and integrate emotional responses.

But in addition to a playful eye, these connections require a mindful eye. At the heart of mindfulness are presence, awareness, and openness, qualities that we can acquire with practice. Through mindfulness, we can recognize the inevitability of constant change, learn to accept life's contradictions and uncertainties, and cultivate the ability to hold them, along with our emotions, while still noticing the silence and sound, the light and dark around and within us.

A mindful eye also requires a willingness to expose our vulnerabilities, the ground of intimacy or "into-me-see," as the quip goes. The "me" in question may be myself, my partner, or indeed a museum exhibit, which not only reveals itself to us but also allows us to reveal ourselves to it.

In turn, over time, discovery and connection lead to insight: seeing the "true" nature of things, observing without attachment, and developing the capacity for awareness, whether comfortable, uncomfortable, or merely neutral.

By melding the quiet and introspective with the loud and boisterous, the disciplined with the uninhibited, the humorous with the serious, the practices in this book are intended to open a playful portal to mindfulness and serve as a practical guide in the search for meaning.

If all this seems a wildly overambitious goal for a museum visit, recall that the word *museum* comes from the Greek *museion*, the seat of the muses, or the nine goddesses of classical mythology who were the source of human inspiration. As museum professionals increasingly recognize the value of experimental approaches to visitor engagement, we can reimagine the museum as a contemplative space for inquiring into existential questions; an intimate space to experience compassion for ourselves and others; and a playful space in which to encounter new ways of seeing, being, and relating—in short, a place where we become more alive to life and its challenges and opportunities.

What we practice in the museum can also be practiced beyond its walls. It's our hope that the adventures of body, mind, vision, imagination,

and action that visitors embark on in the museum will continue after they leave. In fact, most of the 101 practices have been designed to be experienced with *any* exhibit, whether it's a Hokusai painting, a dinosaur skeleton, or a famous pair of shoes. As a result, the practices can just as easily be applied to the things we come across in everyday life. Objects will always beckon us to communicate with them in our (and their) own personal ways. Through a playful and a mindful eye, every object and image as well as every situation and relationship can be a source of discovery, connection, and insight.

Welcome

This book is a companion guide to museums and galleries as spaces to explore empowering, exciting ways of seeing and being. It's designed to encourage discovery and deep connections—with ourselves, with others, and with the world around us.

Right now, you might be in one of the Smithsonian museums, in another museum, or, indeed, anywhere but a museum. Each of the 101 activities in this book can be experienced in all these contexts, and with any object, artifact, or artwork. Thirty of the activities showcase a diverse range of memorable exhibits from the twenty-one museums and galleries that make up the Smithsonian Institution, the world's largest museum, education, and research complex. A short description of each artifact is included at the end of the book.

Wherever you are, and whichever activities or exhibits you choose to explore, all you need is a spirit of curiosity, an openness to wonder, and a willingness to dance at the edges of habit and convention.

Solo and Partners Activities
Each activity or practice (a term that highlights the value of returning to activities over time) has two versions: a "solo" one for individuals and

a "partners" one to encourage interaction and cocreation with others. While partners practices are designed to be independent from the solos, some require you to carry out a solo practice initially. We recommend you always read the solo instructions first.

Whether your partner is someone you know well or a stranger you've just met, sharing personal experiences with respect, sensitivity, and discretion can be a powerful way to engage with exhibits and each other. As many of the practices require a degree of trust and connection, check in with yourself and your partner to be sure you both feel comfortable with a proposed activity. Regard the instructions as invitations and inspirations. If you aren't comfortable with an activity, modify it or move on to another.

Body, Mind, Vision, Imagination, and Action

The 101 practices are presented in five sections, each highlighting a different aspect of experience, but all are grounded in mindfulness: inviting you to be present here and now, practicing attention, compassion, creativity, and playfulness. Body practices explore how our bodies both respond to and affect our encounters with exhibits. Practices in the Mind section focus on the endless stream of thoughts and feelings that

animate our inner world. The Vision section investigates mechanisms of visual perception and patterns of perspective. Imagination practices invite you to transcend the limits of knowledge and circumstance. In the final section of the book, Action practices dissolve the division between perception and performance and challenge you to become a performer, maker, or curator.

Of course, an encounter with any exhibit in a museum space always involves multiple—if not all five—aspects of experience simultaneously. For this reason, we generally use the term *engaging with* rather than *looking at* or *viewing* an exhibit.

This is not a book to be read cover to cover. We invite you to jump into the sections or activities you find most compelling.

Before you start . . .

1. Switch off your phone and put it out of reach.

2. Open up to the subtle and playful, the embodied and the magical.

3. Be bold. Dare to make a fool of yourself.

4. Savor the journey and take the time to explore the possibilities each activity offers; just one might make up your entire visit.

5. If you're alone in a museum and want to interact, show courage and invite a stranger to explore some of the practices together (see activity 94, New Connections).

6. Remember to stay within safe limits for your own health and safety and for the well-being of others—and the exhibits.

Enjoy the adventure!

Body

At the most fundamental level, we experience museum spaces and exhibits through the medium of our body—both in motion and at rest. Our being in the world is always felt as sensations throughout the body, not simply through the eyes. These sensations can be subtle or strong, fleeting or prolonged, and they may be perceived as pleasant, unpleasant, or neutral. Embodied experiences form the ground on which we build a relationship with an exhibit. The practices in this section are intended to help develop your awareness of this ground and its role in your museum visit.

Arriving

SOLO

It's time to arrive in the here and now and get ready to play. Close your eyes. Bring attention to your breath. Fully exhale and then draw in a deep breath through your nose.

With your mouth slightly opened, exhale completely. Take in another deep breath through your nose. As you breathe out through your mouth, soften your face, neck, and shoulders, releasing any tension there.

Prepare to connect with the space, with the exhibits, with yourself, and perhaps with others.

PARTNERS

After each of you completes the SOLO practice, look into each other's eyes and share a smile.

Body

#1

Attending to the Body

SOLO

What kind of physical sensations are you feeling in your body at this moment? Close your eyes and scan your body from the top of your head to the tips of your toes. Notice pleasant, unpleasant, and neutral sensations in your various body parts. How many different sensations can you identify?

Now engage with an exhibit and be attentive to any changes, however subtle, in the physical sensations you experience.

PARTNERS

As you engage with an exhibit, take turns describing to each other the physical sensations you're experiencing. There may be no apparent connection between these sensations and the exhibit, but you can speculate about this.

Body

#2

The Flow of Life

SOLO

The museum space is a body through which many things flow, including people, air, information, and ideas. Just like the museum, many things constantly flow through you: air, water, blood, thoughts, and feelings.

Place a hand on different parts of your body to sense what flows beneath the skin. Where can you feel the flow of breath, blood, and water?

You are one small particle within a vast and ultimately infinite flow. To remind yourself of this connection, from time to time, take a moment to feel what flows through and within you.

PARTNERS

Explore the flows within each other's body. If you're both comfortable, place a hand, or just your fingertips, on different parts of your partner's body. Where can you feel the flow of breath and the flow of blood?

Body

#3

The Other Senses

SOLO

Close your eyes and keep them closed. Use your other senses to engage with the space around you and any nearby exhibits. What can you hear, smell, feel, sense on and in the body, and perhaps even taste? Try this for at least three minutes.

PARTNERS

Partner A keeps their eyes closed. Partner B guides A through the museum with a hand on their shoulder or arm. Partner B describes the exhibits and the spaces they encounter.

After five minutes, change roles. What do you notice? How does each role affect your experience of the environment and the relationship with your partner?

Body
#4

Gravitational Bodies

SOLO

You're aboard the space shuttle, far above the Earth, weightless. Unbuckle your seat belt and float around the cabin. As you surrender to the weightlessness of your body, notice that your heart and mind are weightless too. The feelings and thoughts that were so heavy back on Earth are still present, but now they are as light as a feather. Watch them float away from you.

PARTNERS

You've both completed your mission in space and have just disembarked from the space shuttle. Once again, you're firmly anchored to the Earth. Reacquaint yourselves with its gravity. Lift your limbs, take a few steps, and jump as you appreciate how reliable and useful gravity is. As your partner relaxes their limbs, feel the weight as you lift one of their arms or legs.

Body

#5

Space shuttle *Discovery* on display at the Smithsonian's National Air and Space Museum Udvar-Hazy Center, 2020.

Zoom In

SOLO

Position yourself as far away as possible from an exhibit while still keeping it in view. As you take some deep breaths, notice the space between you and the exhibit.

When you're ready, take a deep breath and move a little closer toward the exhibit. Remain still.

Notice your breath, acknowledge the distance, and explore this new perspective. Continue at your own pace until you're as close as possible to the exhibit. Engage with it at this intimate distance. How has your relationship with the exhibit changed since you started to approach it?

PARTNERS

Begin alongside each other and then follow the SOLO instructions, taking turns to decide when to move forward and when to rest.

Body

#6

Little Detours

SOLO

How do you move between the exhibits in a museum? Do you take the shortest possible route between two points (a.k.a. a straight line)? If instead you move along a curved line, or take a zigzag route, how will it affect the way you experience the space and its exhibits? What other ways are there to move from one exhibit to another?

PARTNERS

Partner A takes a nonlinear route to the next exhibit. Partner B follows alongside. Swap roles as you move on to the next exhibit. Continue swapping roles for at least the next two exhibits.

Body

#7

Horizontal Arc

SOLO

Position yourself to one side of an exhibit. Follow an imaginary arc around it as far as you can. How many degrees does your arc have? Maybe 180, or perhaps 360 if the exhibit is freestanding? As you move slowly along the arc, keep your gaze fixed on the exhibit. Cherish each degree of the arc and the subtly different perspective each one offers. What is revealed that you would have otherwise missed?

PARTNERS

Begin at opposite ends of an imaginary arc around an exhibit, each of you moving at your own pace. At the point on the arc where you meet, stop and engage with the exhibit together from this perspective.

Body

#8

Take a Seat

SOLO

As a posture midway between lying and standing—half at ease, half alert—sitting encourages you to slow down and spend more time with an exhibit.

Most museums provide only a limited amount of fixed seating, but many lend out portable chairs—and there's always the floor. Find a comfortable sitting position and feel your body at rest. What is it like to engage with the exhibit while you're sitting compared to standing?

PARTNERS

Sit down together in front of an exhibit, shifting attention back and forth between the exhibit and each other. How does it change your relationship to the exhibit and each other if one of you stands up?

Body
#9

Rockin' It!

SOLO

Whether you're seated or standing, start rocking your body back and forth. Find a smooth, effortless rhythm. Explore which parts of your body are the sources of the rocking motion. Bring your attention to these areas. Does the rocking change when you become conscious of its sources?

PARTNERS

Follow the SOLO instructions and do some rocking together. You can rock toward each other, toward an exhibit, or alternate your rocking between each other and the exhibit.

At the end of the practice, tell your partner they rock! Make sure to tell them why.

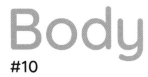

Body

#10

Reclining rocking chair designed by Antonio Volpe, ca. 1905.

Breath-Held View

SOLO

In some yogic practices, there are two ways of holding your breath: after inhaling and after exhaling. For this practice, you can only look at an exhibit for as long as you can hold your inhaled breath. Use this precious time to give your full attention to the exhibit. When you release the breath, you must also let go of the exhibit and move on. Alternatively, after exhaling, don't breathe in. Only look at the exhibit as long as you can resist inhaling again.

Is there a difference in the way these two breath-holding techniques affect your experience of an exhibit?

PARTNERS

As you both engage with an exhibit, adopt a complementary breathing pattern in which one of you inhales while the other person exhales. Using hand gestures can help coordinate your breathing and establish a comfortable rhythm. If you find this difficult, that's OK. It takes a little practice.

Body

#11

Breath-Eye Tracking

SOLO

As you engage with an exhibit, coordinate your eye movements with your breath. With each inhaled breath, move your eyes to a new element, such as a shape, line, color, tone, or detail of interest. With each exhaled breath, move your eyes to another element in the exhibit.

Experience the exhibit with the rhythm of your breath. Notice the short pause between an inhaled and exhaled breath in which there is no breath at all. What happens to your gaze in that moment?

PARTNERS

Position yourselves alongside each other as you both engage with the same exhibit. Independently of each other, as described in the SOLO practice, move your gaze to a new element with each inhaled and exhaled breath. After ten breaths, compare the things you each looked at and the order in which you looked at them.

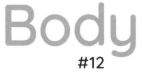

Body

#12

The Lion's Breath

SOLO

The lion's breath is a yoga breathing technique. Breathe in deeply through the nose. Then, as you exhale, make a voiceless roar from the back of your throat, scowl fiercely, and stick out your tongue as far as you can. To daunt others and detox yourself, repeat the whole cycle five times.

PARTNERS

Face your partner, look into their eyes, synchronize your breathing, and do five cycles of the lion's breath. Allow yourself at least one loud roar.

Body

#13

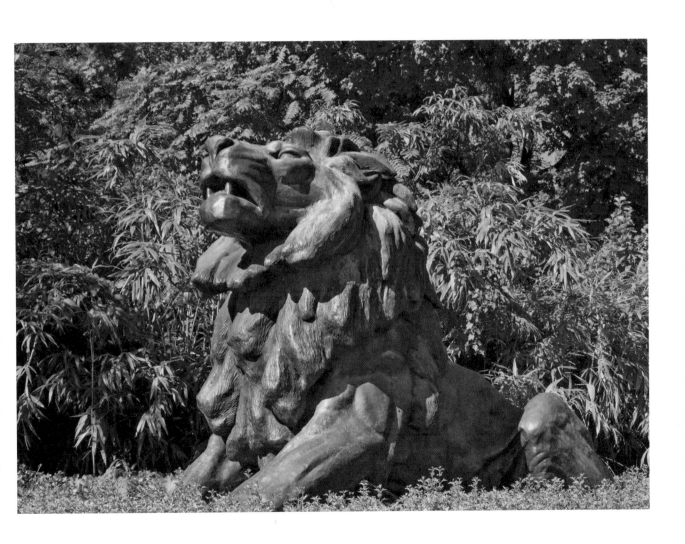

Lion statue at the front gate of the Smithsonian's National Zoo & Conservation Biology Institute, Washington, DC.

Hyperventilation

SOLO

Rapid, deep breathing can alter your perceptions. It can also lead to light-headedness, so make sure you're in a safe position, sitting or lying down or leaning against a support.

As you engage with an exhibit, take twenty rapid, deep breaths. Then take ten slow, very deep breaths. Finish up with another ten rapid, deep breaths. As you return to your normal breathing and heart rate, engage with the exhibit, observing any shifts in your perception.

PARTNERS

As you both engage with the same exhibit, remain alongside each other, with shoulders and arms touching. Sharing the same rhythm, do the twenty-ten-ten breathing exercise described in the SOLO practice. Continue to engage with the exhibit in silence until your breathing and heart rate return to normal.

Body

#14

Softness and Tension

SOLO

Some exhibits seem to express tension or rigidity, while others exude softness or fluidity. And some have both qualities.

If you notice tension, however subtle it may be in the exhibit, gradually tense all the muscles in your body. Begin with those in your forehead and then move progressively down to your squeezed eyes, contorted mouth, hunched shoulders, outstretched arms, clenched fists, stretched legs, and curled-up toes. If the exhibit radiates softness, soften your entire body, relaxing each body part from the top of your head to the tips of your toes. If the object has qualities of both tension and softness, find a way to express both at the same time.

Now that you've empathized with the exhibit, do you feel closer and more connected to it?

PARTNERS

Partner A tells Partner B where they've identified tension or softness in an exhibit (e.g., "I see tension in the plinth"; "I sense softness in the flower"; . . .) and instructs Partner B to tense or soften one or more body parts to mimic the exhibit. Partner A also describes the corresponding level of tension required in each body part on a scale from zero (supersoft) to ten (hypertense).

Body

#15

Pressure Cooker

SOLO

Sometimes it feels as if the whole world is one big pressure cooker. Let's release some of that pressure. Breathe in as deeply as you can, completely filling your lungs with air. Hold your breath and let the pressure build inside you. When you're ready, slowly release the breath through your mouth with a hissing sound, soften your body, and feel the drop in pressure. Do this three times, and then close your eyes and imagine the whole world feeling the same sense of relief.

PARTNERS

Facing each other, take a deep breath and compete to see who can hold their breath longest. When you can't hold your breath any longer, press the release valve conveniently located on top of your head. Let your breath slowly escape through your mouth with a loud hiss.

Tell each other what causes pressure in your own life and what you do to release it.

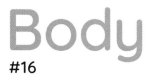

Body

#16

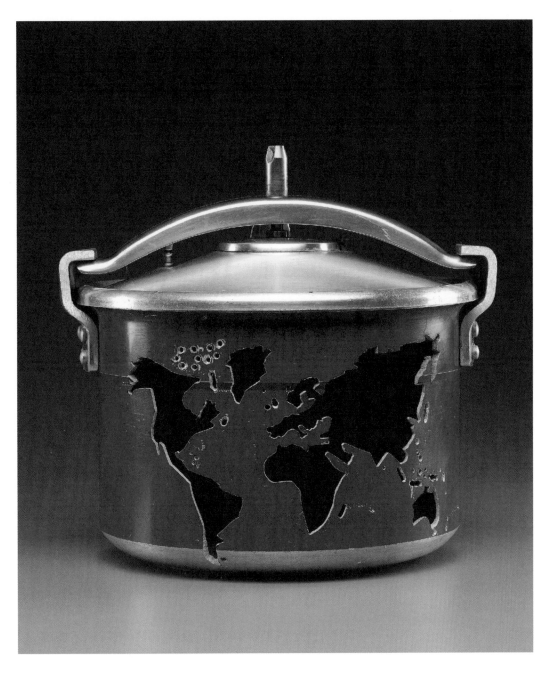

Gluten-Free, Low-Carb Zen

SOLO

In every bite of fruit or vegetable, the sun, water, air, and earth are present. Recognize the interconnectedness of all things and savor the taste of the universe.

The elements stored in the fruits and vegetables you eat become part of your body. Ultimately, even your feelings and thoughts are formed by what you eat. Which elements shape your state of mind in this moment? Are your thoughts solid like the earth, playful like water, heated like fire, or expansive like air?

PARTNERS

Using all the ingredients illustrated on the "Hans Sloane" plate, create a delectable dish together. To make it even more special, each of you should contribute one extra ingredient. What's the name of this culinary delight? Would you eat it yourself?

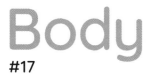

Body

#17

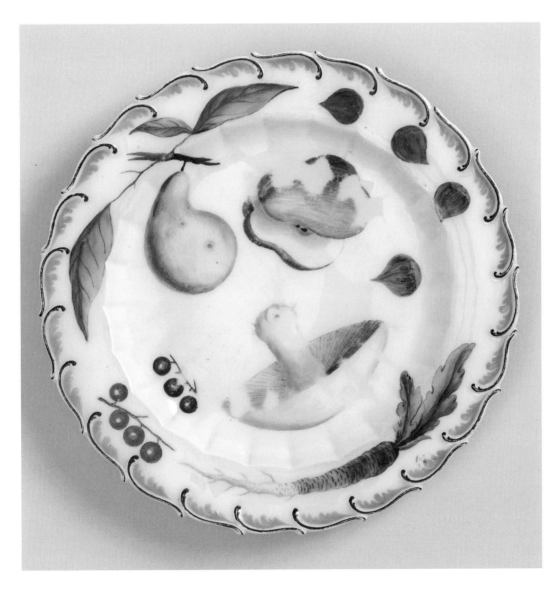

Back to Front to Back

SOLO

Position yourself in front of an exhibit. Notice the parts of your body that are facing the exhibit and how each time you inhale, your upper body expands toward it. Now turn your back to the exhibit. Sense the entire back of your body and realize that your breath also expands your back toward the exhibit.

What do you learn about yourself and the exhibit by turning away from it?

PARTNERS

Position yourselves back-to-back against each other, with one of you facing the exhibit and the other facing away. Synchronize your breathing. Continue until the partner facing the exhibit decides to switch roles. Repeat for at least one more round.

How does this practice affect your relationship to the exhibit and to each other?

Body

#18

Trigger Party

SOLO

Negative emotions can offer an opportunity for self-knowledge and wisdom. Find an exhibit that triggers—subtly or strongly—anger, sadness, fear, or shame. How and where in your body do you feel the emotion? Remember to breathe as you witness your bodily sensations. Why do you think the exhibit triggers this emotion?

Thank the exhibit for triggering you and thus offering a key to self-discovery.

PARTNERS

Decide which one of these emotions you'll explore together: anger, sadness, fear, or shame. Approach the nearest exhibit and engage with it in silence for about one minute as you open yourself to the possibility of sensing the emotion in yourself.

After breaking the silence, share your experiences. How intensely did you sense the emotion? Which aspects of the exhibit might have elicited it? Could the same exhibit trigger a different emotion in you?

Body
#19

Guardian at the Gate

SOLO

Clench your fist and grimace ferociously to mirror the posture of the guardian figure. Hold this position for one minute, remembering to breathe as you do. What feelings and thoughts does it evoke? If anger arises, what character does it have? Is it destructive or protective?

PARTNERS

As you mirror both the expression and posture of the guardian figure, look into your partner's eyes for one minute, continuing to breathe as you do. Without telling each other, decide whether you are your partner's enemy or ally.

Body

#20

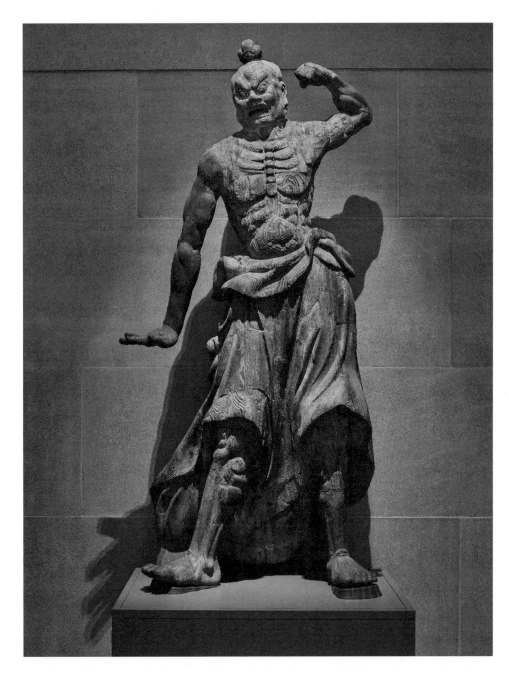

Guardian figure, artist unknown, ca. 1235.

Mind

Mind practices highlight the endless stream of thoughts and feelings that animate our inner world. We may not be able to stop this rushing torrent, but we can find a haven on its banks where we won't be swept away. The activities in this section are designed to help you observe the torrent and find that elusive haven.

Mirror Mind

As you engage with an exhibit, pay attention to your thoughts, feelings, and sensations. No matter how strange or unrelated to the exhibit they seem, be aware of them, especially those aspects of consciousness that are subtle and difficult to detect. Focus carefully until you recognize the presence of pleasant, unpleasant, and neutral thoughts, feelings, and sensations.

PARTNERS

As Partner A follows the SOLO instructions, Partner B asks the following questions:

1. What is a pleasant thought, feeling, or sensation that you're experiencing right now?
2. What is an unpleasant thought, feeling, or sensation that you're experiencing right now?

Partner A responds and continues to engage with the same exhibit. Partner B repeats the questions at least twice before swapping roles.

As you answer the questions, take note of how much of your experience you're willing to share and how much you censor.

Mind

#21

Pure Perception

SOLO

Engage with an exhibit, surrendering yourself to its colors, shapes, textures, and other qualities. Ask no questions, make no judgments or interpretations. If questions, judgments, and interpretations arise, don't attend to them. When thoughts and feelings intrude, acknowledge them and then let them go. When they return, give them a smile and send them on their way again.

PARTNERS

Take turns, one word, phrase, or sentence at a time, to describe an exhibit using only sensory information, such as size, shape, form, color, and texture. Avoid labels, names, explanations, and evaluations. How long can you continue before one of you attaches a label, names an element, explains something, or makes a judgment?

Mind

Mind's Eye

SOLO

Look at an exhibit, then close your eyes. Continue to "see" the exhibit in your mind's eye. Recall it in as much detail as you can. Are you now the exhibit's curator or in a sense its creator? What is the relationship between the exhibit in the museum and the one in your mind? Does the exhibit even exist independently of your mind?

PARTNERS

Take turns closing your eyes and recalling aloud your partner's appearance and clothing. How different is your memory from reality?

#23

Inner Witness

SOLO

You are more than just your sensations, thoughts, and feelings. As they arise, you can also be their witness, telling yourself: "I'm noticing that I'm having a sensation/thought/feeling that . . ." No matter what happens around or within you, this inner witness is always unaffected, quietly observing from the still center of your being.

As you're engaging with an exhibit, observe yourself engaging with it. Can you maintain your inner witness, keeping continuous track of your sensations, thoughts, and feelings?

PARTNERS

Activating your inner witness as described in the SOLO practice is a powerful way to bring you into the present moment. As you both engage with the same exhibit, is it possible for each of you to be fully present with yourself, your partner, and the exhibit? Can you witness your partner witnessing?

#24

Invisible Fires

SOLO

We all possess our own invisible fires. Surrender to your inner fire and feel yourself being purified by it. Let its benevolent flames burn away the pain and sorrow that no longer serve you. Which memories, experiences, or emotions will you ask the flames to burn?

PARTNERS

After you've both completed the SOLO practice, show each other the ashes that remain. Explain what they mean. Will you each now scatter the ashes or hold on to them?

Mind

#25

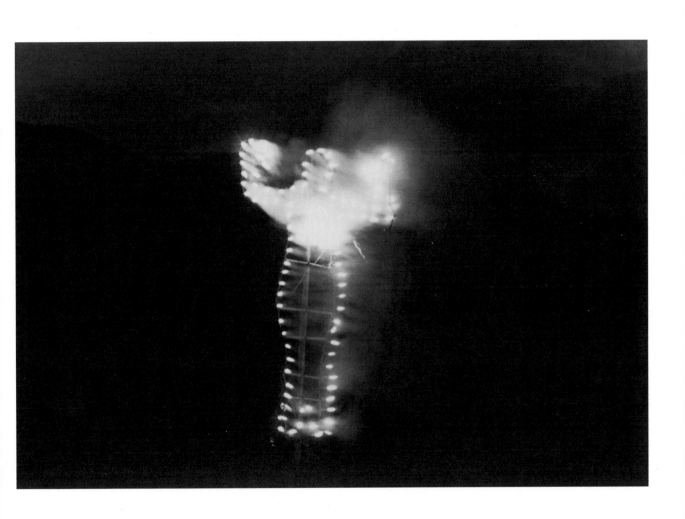

Ana Mendieta, *Anima* (*Alma/Soul*), 1976.

Slow Reveal

SOLO

Studies show that many visitors spend just ten seconds with an exhibit before moving on. Commit to taking at least five minutes to get to know an exhibit, as if it were the only one in the museum.

The exhibit may only reveal itself slowly. Can you give it as much attention as you would your child, lover, or someone you've always wanted to meet?

PARTNERS

Spending an extended period of time with a partner in the presence of an exhibit can be a very intimate experience, especially if all three of you remain silent. Who's the first to break the silence? What does the experience reveal to you about the exhibit, your partner, and yourself?

Getting to Know You

SOLO

Building a relationship takes time. Whenever we return to an exhibit, we have an opportunity to deepen our relationship with it by discovering new facets of both the exhibit and ourselves.

Whether it's an exhibit you're already familiar with or one you're seeing for the first time, make sure to return to it at least once today. If you have the opportunity, make multiple visits over the course of days, weeks, and months. There's no end to what you can discover.

What new discoveries do you make about the exhibit, yourself, and your relationship after each encounter?

PARTNERS

Celebrate that you already know each other, at least a little, and that you don't need to start from zero. To discover more about each other, share your answers to this question: If you could have any superpower for a day, what would it be and how would you use it?

Mind

#27

Courage and Determination

SOLO

Harriet Tubman was born into slavery, escaped, and then assisted others in gaining their freedom. She fought tirelessly throughout her life to free enslaved African Americans and to end the system of slavery. After the abolition of slavery in 1865, Tubman continued to champion the rights of African Americans and other marginalized people throughout her life. Make eye contact with Harriet Tubman as you recognize her unbounded commitment to the cause of freedom.

You have the opportunity to ask her one question. What do you say to her?

PARTNERS

Sit down together in a sharing circle with Harriet Tubman and respond to her question, "What really matters to you?"

Mind

#28

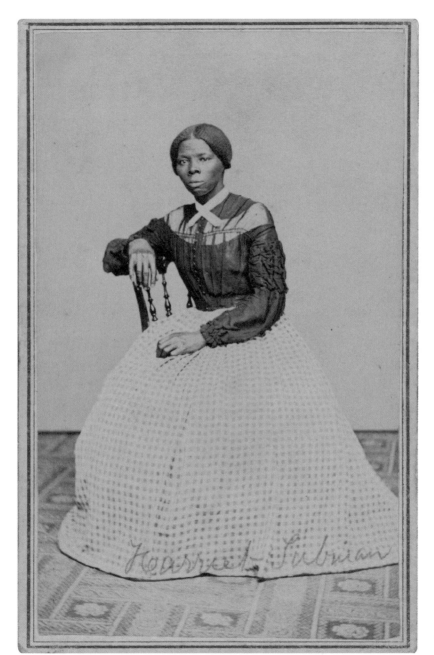

Carte de visite portrait of Harriet Tubman, ca. 1868.

Finding Oneself

SOLO

Search the museum for the exhibit that most closely reflects who you are or who you'd like to be. Why and how are you and the exhibit such a good fit?

PARTNERS

Separately, find the exhibit that you think most closely reflects who your partner is or who your partner would like to be. Show each other the exhibits and describe your reasons for choosing them.

Mind

Constant Flux

SOLO

Position yourself in a quiet corner where you can observe whatever moves or changes around you. Compare the motion of people with the stillness of the floors, walls, and ceilings as well as most, if not all, the exhibits.

Although it may not be apparent, everything is in motion and constant flux, from each atom vibrating at hyper speed to our solar system racing through the Milky Way at almost half a million miles an hour.

Can you also sense the deep stillness that lies within all things and contains all motion?

PARTNERS

Observe together the movements and changes around and within you. Try to discern even the subtlest ones: a shift in the light, dust motes in the air, the blink of an eyelid. Then reflect on the fact that, for the moment, you and your partner are together, but sooner or later—at the end of this practice, at the end of the day, or at the end of your life—you will separate. Honor this moment of shared presence.

Mind

#30

Fragrant Dreams

SOLO

When you hear the words *flower garden*, which garden, real or imaginary, comes to mind? Close your eyes and relish its colors, fragrances, and sounds. What would it be like to experience this garden as a bird, a bee, a snail, or a cat?

PARTNERS

Share a memory or a daydream of a special time in a flower garden.

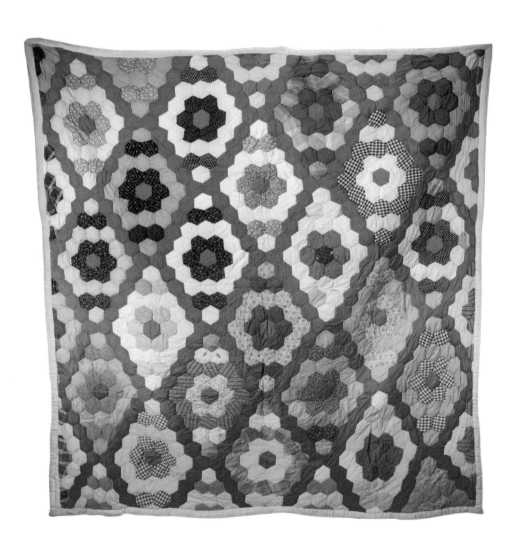

Emma Russell, "Grandmother's Flower Garden" quilt, 1987.

Sounds of Silence

SOLO

Entrust yourself to the silence of an exhibit. Don't speak to anyone, including yourself. Quiet your mind. Try to avoid even verbal thought. Still your body. Hush your breath. Let the silence in you merge with the silence of the exhibit.

Listen carefully and allow the exhibit to share its silences and the secret sounds those silences contain. If you sink deep into silence, you're sure to hear those sounds.

PARTNERS

After separately following the SOLO instructions, share with each other the sounds and silences you each heard in an exhibit. Then listen carefully to each other's bodies. In which parts can you hear sound? Can you also hear your partner's deep silence?

Mind

#32

Museum Wisdom

SOLO

Museum exhibits can offer helpful answers to life's difficult questions. Seek advice for a current personal issue from an exhibit. To be on the safe side, get a second opinion from another exhibit. Do they agree with each other? If they disagree, or you just don't like their advice, seek a third opinion.

PARTNERS

Entrust each other with a personal question you're comfortable to pose. Each of you then seeks out at least one exhibit to consult, bearing in mind that some exhibits may not have visitors' best interests at heart.

#33

Q&A

SOLO

Museum exhibits are curious beings. Here are the questions they ask most frequently: Who are you? Why are you here? Why are you looking at me? Others may ask, Why aren't you looking at me? But they ask more personal questions too.

If at first an exhibit doesn't ask a question, drop into a deeper silence to hear it. Answer as truthfully as you can.

PARTNERS

Spend some minutes apart from each other, gathering questions from various exhibits. Then get together again and share the most mischievous questions you've been asked. If you feel compelled to respond, return together to the exhibits and enlighten them.

Mind

#34

4

Hidden Gems

SOLO

There can be a certain beauty even in the most seemingly hideous or boring things. Find an exhibit you dislike or find uninteresting. Give it some attention and find the one aspect, however tiny, that you can appreciate.

PARTNERS

Find an exhibit you are both indifferent toward or actively dislike. Compete with each other to find its hidden delights. Which of you will find the exhibit's most fabulously beautiful qualities?

#35

Guiding Lights

SOLO

Sometimes we appreciate the journey, and at other times, we're eager to arrive at our destination.

Who or what is your guiding light? How does it illuminate your journey? Where do you want it to take you?

PARTNERS

Share a secret wish with your partner. If you're not comfortable articulating it, you can still communicate it telepathically. On a scale of one to ten, with one an easy-to-disclose wish and ten the most private of all your secret wishes, how do you rate the wish you just shared?

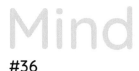

Mind

#36

Ralph A. Blakelock, *The Three Trees*, ca. 1885.

Breathing in Light

SOLO

Just as you receive breath through your nose and mouth, you receive light through your eyes. An image of an exhibit comes to you through your eyes as if you're breathing in light.

With each inhaled breath, feel how an exhibit's qualities, such as its form, shape, and color, enter through your eyes. With each exhaled breath, observe how your attention reaches out to the exhibit. Repeat, breathing in the exhibit and then, as you breathe out, returning your attention to the exhibit, until you find a comfortable and satisfying rhythm.

PARTNERS

Face each other. As you breathe out, direct your attention to your partner. As you breathe in, direct your attention to yourself—to your bodily sensations, thoughts, and feelings. Notice whether it's easier to focus attention on yourself or your partner.

Mind

#37

Gratitude

You're alive. You're engaging with an exhibit in a museum, or at the very least, you're reading about engaging with an exhibit in a museum. You're intensely aware of the preciousness of this fleeting moment and of the gift of life that you've been granted.

What does the exhibit remind you of that you're grateful for? Tell the exhibit and whisper your gratitude to it for reminding you.

PARTNERS

With an exhibit as your official witness, share with each other three things you're grateful for in life.

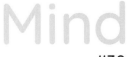

#38

My Bucking Bronco

SOLO

Life can sometimes seem as if it's trying to throw us off its back, just like a wild horse. Who or what is the bucking bronco that you're riding? Or is a bronco riding you?

PARTNERS

Describe to each other one situation in which you tamed the bronco and another situation in which you were bucked off.

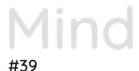

Mind

#39

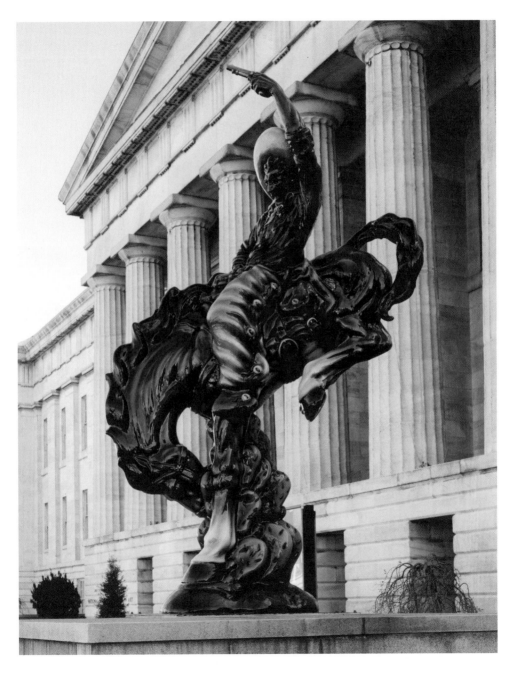

Luis Jiménez, *Vaquero*, modeled in 1980 and cast in 1990.

Golden Orb

SOLO

Close your eyes and visualize a golden orb glowing in your chest. Feel its radiant light shining like an inner sun, and then let its radiance expand to fill your entire body. Bask in its warm light as its rays shine beyond your physical body to illuminate the space around you.

PARTNERS

One of you forms an imaginary golden orb between your hands. It can be as large or small, as cold or hot as you wish. Pass the orb back and forth between the two of you. Notice how its qualities shift each time it changes hands.

At the end of the practice, how will you both part from the orb?

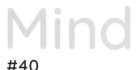

Mind

#40

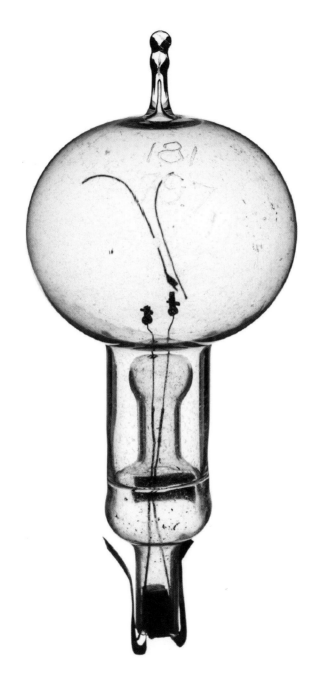

Carbon-filament light bulb used by Thomas Edison, 1879.

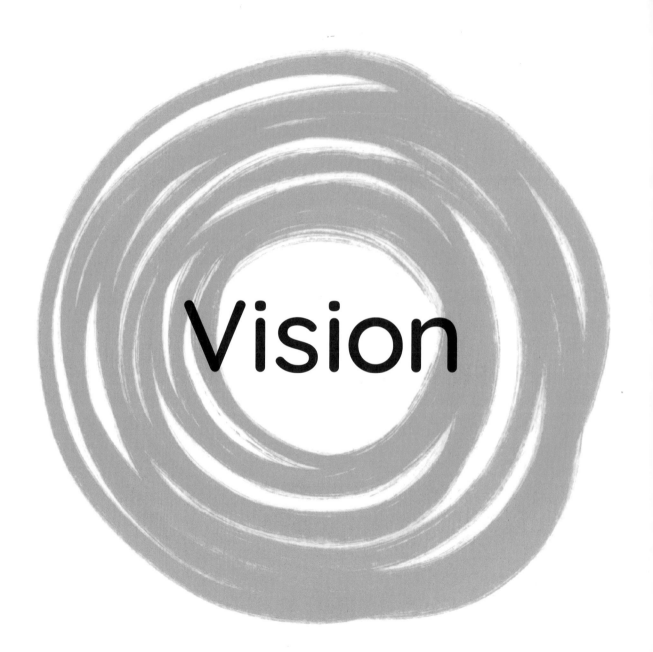

Vision

Vision practices invite you to explore your habits of visual perception and the patterns of perspective that condition your view of the world, perhaps without you being aware of them. The practices challenge you to free yourself from habit and convention and experiment with alternative ways of seeing exhibits, museum spaces, other visitors, and yourself.

Thesaurus Eyes

There are many ways of engaging with an exhibit: We can examine, observe, contemplate, gaze, glance, scrutinize, stare, gape, monitor, or even leer at it. These are just a few of the scores of English verbs that describe visual behaviors.

From this list, choose two contrasting verbs to curate an encounter with an exhibit. For example, you might first glance at an exhibit and then contemplate it. How do these different viewing behaviors affect your experience of the exhibit?

PARTNERS

Without telling each other which ones you choose, select two verbs describing visual behavior from the SOLO list. Turn to an exhibit and engage with it through one of these two lenses. After some time in silence, engage with each other through the same lens. Can you guess which lens your partner is using? Then repeat the process with the second verb.

Vision

#41

The Naming of Parts

SOLO

Everything is an assemblage of many different parts at a range of scales, from the very large to the invisibly small. "Disassemble" an exhibit, listing its parts in order from the largest to the smallest. As you move closer to the exhibit, which additional visible parts or elements do you notice? In principle, there's no limit to the number of parts that can be identified and named.

PARTNERS

Collaborate or compete to see how many parts you can list in sixty seconds. What are the benefits and costs of naming parts?

Vision

#42

Picture Perfect

SOLO

A friend who has never visited your country asks you to send them a photograph or short video of the place you call home.

What does "home" mean to you? What image would you choose to illustrate it? Which aspects of this home would you highlight or hide?

PARTNERS

Describe to each other one image that would best attract tourists to your hometown, and another image guaranteed to keep them away.

Vision

#43

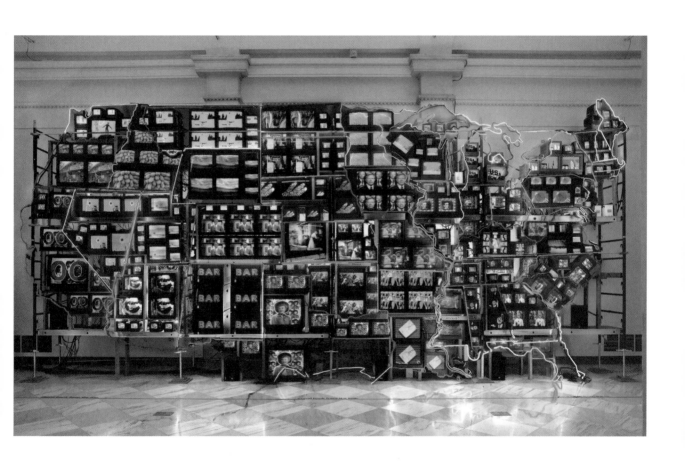

Nam June Paik, *Electronic Superhighway: Continental U.S., Alaska, Hawai'i*, 1995.

Cyclops

SOLO

With both eyes open, vision is stereoscopic, revealing spatial depth. Close one eye. Now you have monoscopic vision, and your visual field flattens out.

Explore an exhibit with just one eye open for twenty seconds. Then switch eyes and continue to engage with the exhibit. How does the subtle change of perspective affect the experience?

PARTNERS

Partner A selects an exhibit to engage with. Partner B, positioned behind A, curates a one-minute visual experience for A by unpredictably covering A's left eye or right eye or leaving both eyes uncovered.

If you could use only your nondominant eye to view an exhibit, what would you gain?

Vision

#44

Fragments of Light

SOLO

Close your eyes and loosely cup your hands over them. With hands still cupped, open your eyes. Even through small gaps between your fingers, the world presents complex and exciting sights. Keeping your hands loosely cupped over your eyes, turn very slowly in a circle, exploring the space around you and any exhibits it contains. When you feel ready, gently remove your hands, opening yourself up fully to the light.

PARTNERS

Partner A closes their eyes. Partner B guides A to an exhibit. Positioned behind Partner A, Partner B cups their hands loosely over A's closed eyes. Partner B invites A to open their eyes, keep their head still, and describe how many fragments of the exhibit are visible in gaps between B's fingers. What shape are the fragments? Which one contains the most intriguing or pleasing image of the exhibit or its surroundings?

Vision

#45

Honoring the Darkness

SOLO

Our image of the world takes shape through the play of light and dark. To honor the darkness that's always present, even in daylight or an illuminated space, identify the darkest areas around you. Which are the areas of greatest contrast where dark meets light?

Explore one object or area of high contrast and examine how dark and light meet. As you approach more closely, what extra detail can you see along the boundary between dark and light?

PARTNERS

Examine each other's faces and observe how the play of light creates highlights and shadows. One partner then turns their head very slowly from shoulder to shoulder, while the other partner observes how the areas of light and dark shift and morph on their partner's face. Which position produces the highest contrasts between light and dark?

Vision

#46

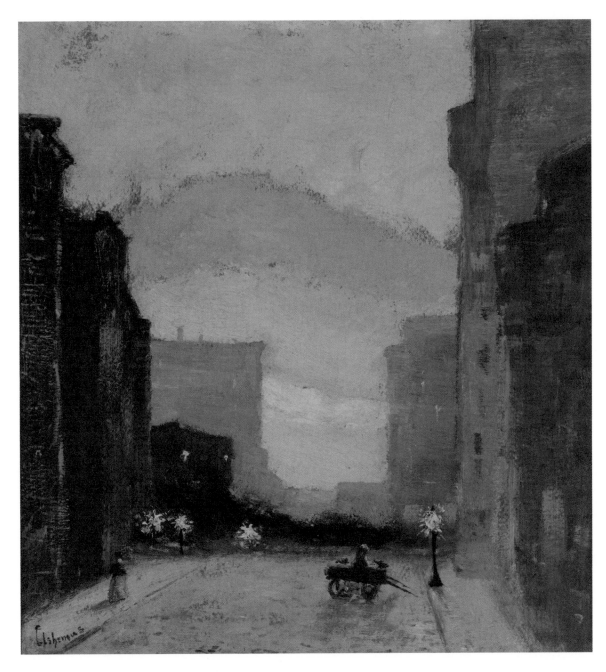

Telescopic Sight

SOLO

Form a telescope with two open fists and look through it at an exhibit. By framing your visual field in this way, you can focus your gaze more sharply. Discover three things in the exhibit that might otherwise have remained unnoticed.

PARTNERS

Following the SOLO practice, place your two open fists against your partner's fists to create a four-hand telescope. Take turns looking through it to discover more details in the exhibit.

Vision

#47

Framed Up

SOLO

Extend the thumbs and index fingers of both hands to make two ninety-degree angles. Now bring the tips of your index fingers to the tips of your thumbs to form a rectangular frame. By adjusting the distance of your hands from your eyes, and closing one eye, aim to compose innovative and unusual images within your picture frame.

Using your frame, create an award-winning picture that captures one or more exhibits in a unique composition.

PARTNERS

Stand or sit alongside each other in front of an exhibit. Partner A creates a picture frame with index fingers and thumbs as described in the SOLO instructions. Closing one eye, Partner A moves the frame until it captures a compelling view of an exhibit. Keeping the picture frame in the same position, Partner A invites Partner B to close one eye and look through the frame.

Describe to each other what you can see through the frame. What discoveries, intentional or accidental, does the frame offer?

Vision

#48

Sacred and Serene

SOLO
From your immediate environment, select one object or exhibit, large or small, close or distant, precious or seemingly worthless. Treat it with the reverence normally reserved for the sacred. How do you respond to and honor it? Do you bow, chant, play the flute, offer a silent prayer, or some other token of deep respect?

PARTNERS
One of you is the sacred mountain, the other is Hokusai's boy. Face each other for some minutes in silence and notice the wonder, the beauty, and the goodness in each other. Then swap roles. Do you prefer being the mountain or the boy?

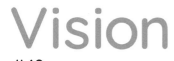

Vision

#49

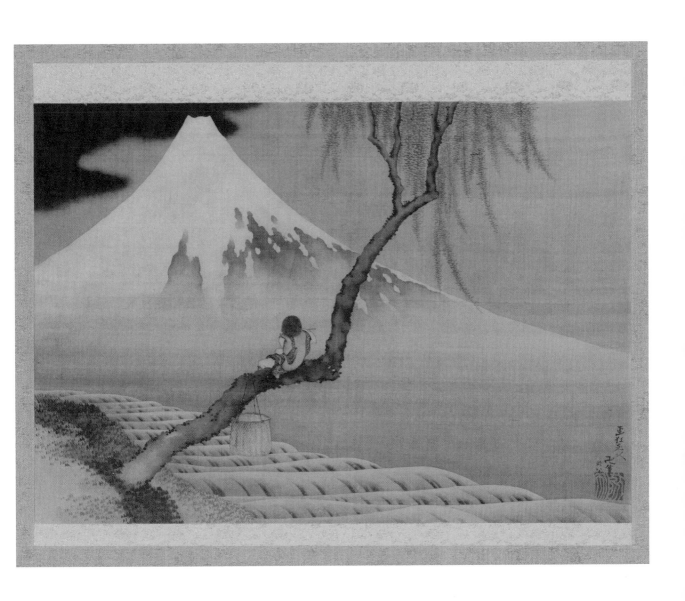

Katsushika Hokusai, *Boy Viewing Mount Fuji*, 1839.

It or You?

SOLO

You can look at an exhibit in two different ways. One is a scientific, objectifying view in which the exhibit is considered as an "it," a material object whose qualities can be measured, described, and manipulated. The other way is an empathic view that cherishes the exhibit as if it were an independent, sentient being, worthy of being addressed as "you."

Switch between these two modes, observing the exhibit first as a thing and then as a fellow being. Notice how your relationship with the exhibit changes according to the viewing mode.

PARTNERS

As you look at each other, switch between the two viewing modes described in the SOLO practice. Begin by adopting the objectifying view for about one minute and then agree to switch simultaneously to the empathic view. After a while, you may both choose to switch again, this time without revealing the change. Can you tell in which mode your partner is viewing you?

Vision

Juggling Act

SOLO

Examine an exhibit. While maintaining your gaze on the exhibit, attend to what surrounds it. With a little practice, you can become a visual juggler, deftly switching attention between the exhibit in your central vision and its surroundings in your peripheral vision.

How does an awareness of the surrounding context change your appreciation of the exhibit?

PARTNERS

Side by side, Partners A and B engage with an exhibit. Partner A keeps their visual focus fixed on the center of the exhibit. Partner B softens their gaze to engage with the exhibit as a whole, without focusing on details. After a minute, swap focus techniques.

Vision

#51

Peacock Eyes

SOLO

Inexplicably, you've been transformed into a peacock, though people around you seem unfazed. Your eye level is now much lower than before, but to make up for it, the peacock eyespots on your tail give you visual superpowers. Some eyes can zoom in on distant objects, others offer superwide views, and still others have X-ray vision. As you strut about, try out your new powers. Maybe you can impress a peahen.

PARTNERS

Enriched and empowered by your peacock vision outlined in the SOLO practice, amaze your partner by describing the minute details of an object around you that only you can see with your superzoom and X-ray eyes.

Vision

#52

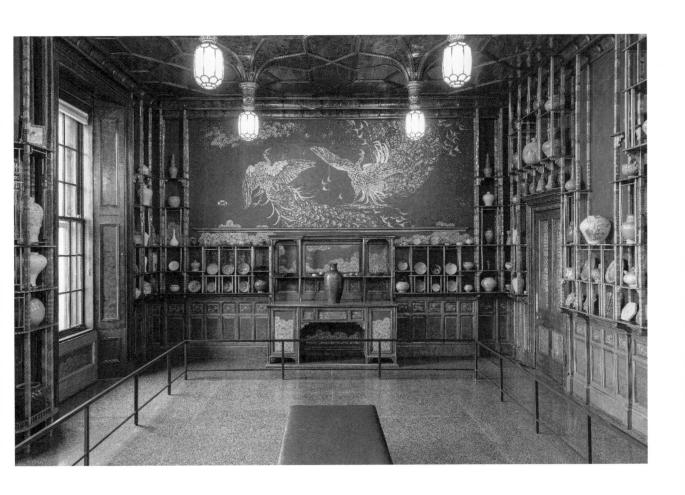

The Peacock Room as reassembled in 1923 in the National Museum of Asian Art, photograph from 2022. This south wall features James McNeill Whistler's *Art and Money; or, the Story of the Room*, painted in 1876.

The Unseen

SOLO

Every object has hidden parts: from the front, you can't see the back; from the top, you can't see the base; and from outside of something opaque, you can't see the inside.

The boundary between the seen and the unseen shifts according to our position, but it's always present. Identify this boundary in an exhibit from your current position and then visualize what lies beyond.

PARTNERS

While Partner A remains in place, Partner B approaches an exhibit to find elements that lie beyond A's field of vision. What can B discover, invisible to A, and however small, that will excite and delight Partner A?

Vision

#53

Divided Focus

SOLO

Focus on a single detail of an exhibit. While keeping your eyes fixed on this detail, direct your mind and body to engage with a different exhibit. Maintain your visual focus on the detail, no matter how much your mind and body turn away or distance themselves from it.

Who will win this inner struggle? Your eyes or your mind and body?

PARTNERS

While Partner A maintains an undivided focus on a single detail of an exhibit, Partner B describes the attractions of other nearby exhibits. How long can Partner A resist the temptation to look away from the detail? Which descriptions offer the most seductive inducements to redirect Partner A's eyes?

Vision

#54

Double Portrait

SOLO

Time travel back to late nineteenth-century Paris to join Edgar Degas and painter and printmaker Mary Cassatt, one of the very few women, and the only American woman, to exhibit with the Impressionists. Go as you are. No need to change or waste time looking for your phone charger.

How do you explain your sudden arrival?

Delighted by your explanation, Mary Cassatt invites you to have your portrait painted with her. She has already decided on her pose. Adopt the pose you'd like for your portrait.

PARTNERS

One partner is a portraitist and the other is the subject. The portraitist carefully poses the subject and then intently inspects them for at least one minute. As the subject continues to hold the pose, share with each other what it feels like to gaze and to be gazed at like this. Then swap roles and repeat.

Vision

#55

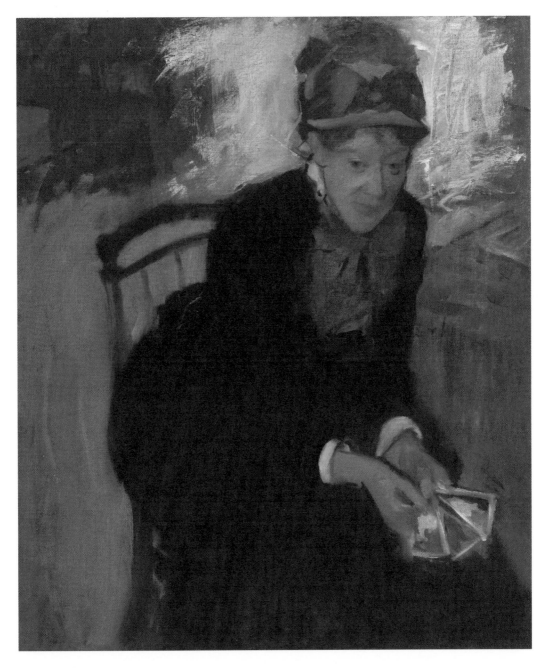

I Spy

SOLO

Select a visual theme and see how many examples you can find in the exhibits and in the space around you. Suggestions for themes include a specific color or shape, human figures or animals, things that look absurd, things you don't understand, or things that seem to be of no significance. Whatever you choose, you're sure to find many instances of it.

PARTNERS

Partner A chooses a theme and finds one example in the nearby exhibits or space. Partner B then has to find another example of the theme in the same surroundings. The partners take turns until one of them is unable to find a new instance.

Vision

#56

Parallax Pointing

SOLO

Close one eye and look at an exhibit. With one arm extended, point your index finger to a spot on the exhibit you find interesting. Now open your eye and close the other one. You haven't moved your finger, but it's now pointing at something else. What contrasts or connections can you find between the first spot you were pointing to and the spot you're pointing at now?

PARTNERS

Partner A closes one eye and points to a detail of an exhibit. Partner B tries to guess exactly what Partner A is pointing at. Try this at different distances from the exhibit to raise or lower the level of difficulty.

Vision

An Enchanted World

SOLO

Each step we take opens a portal to the unknown. Imagine that right in front of you an invisible portal leads to a parallel dimension where the everyday world glows with a magic that you cannot see on this side of the portal. Take a moment to prepare yourself to enter this world of enchantment. Now pass through the portal and marvel at the mysteries that reveal themselves. How are objects transformed? What magical events unfold? When you're ready to leave, be sure to exit through the same portal.

PARTNERS

One of you enters the enchanted world through an imaginary portal, while the other remains outside. The partner inside the enchanted world describes how ordinary objects are transformed by the glow of magic.

Vision

#58

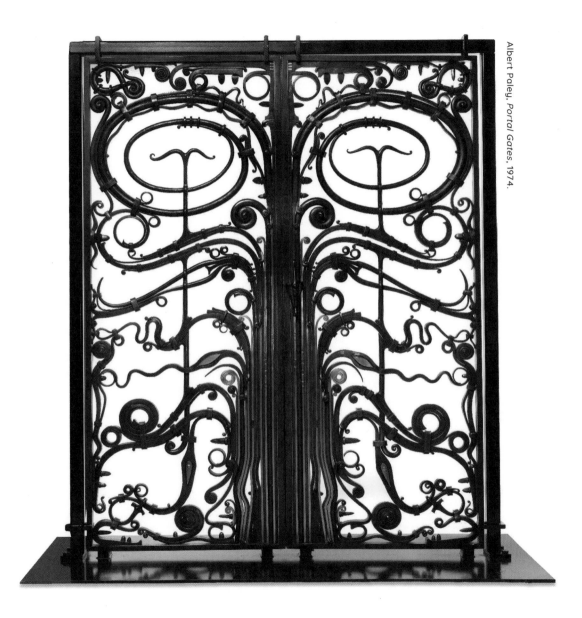

Phosphene Expressionism

SOLO

Fix your gaze on an exhibit for one minute and then close your eyes. You'll probably see an afterimage of the exhibit. You're also going to see dancing particles of light. These are phosphenes released by cells inside the retina. If you gently apply pressure to your closed eyes, you can stimulate the production of more phosphenes. What new visual effects can you observe? Are they entirely abstract or do you see recognizable forms?

PARTNERS

Close your eyes and observe the phosphene light show beneath your eyelids. Describe what you see to your partner. Your partner passes their hands in front of your eyes, experimenting with different distances and speeds. Continue to describe the shapes and colors that appear. How does the movement of the hands affect your light show?

Vision
#59

Gazing with Intent

SOLO

As our purposes change, so do our eye movements. Be aware of your own eye movements as you engage with one exhibit with each of the following purposes:

1. Find evidence for your suspicion that the exhibit is a forgery or replica.
2. Estimate the age of the exhibit (without viewing the label).
3. Identify how the exhibit was produced or constructed.

PARTNERS

As Partner A looks at an exhibit, Partner B examines the movements of Partner A's eyes. Can Partner B track these movements to identify the parts of the exhibit that receive the most attention from Partner A?

Vision

#60

Imagination

Imagination practices invite you to transcend the limits of knowledge or circumstance. In the play space of our imagination, the usual rules and limitations don't apply, so you can invent and explore what lies beyond the everyday. The world around you becomes a launch pad into new realms of possibility.

Lost and Found

SOLO

As you're walking through a part of town you've never visited, you notice an attractive-looking bag on an empty bench. You're astonished to discover it has your name written on it. You look inside. The bag contains a much-loved, long-lost object from your childhood. What is it?

PARTNERS

Tell your partner the story of the object in the bag discovered in the SOLO practice.

Imagination

#61

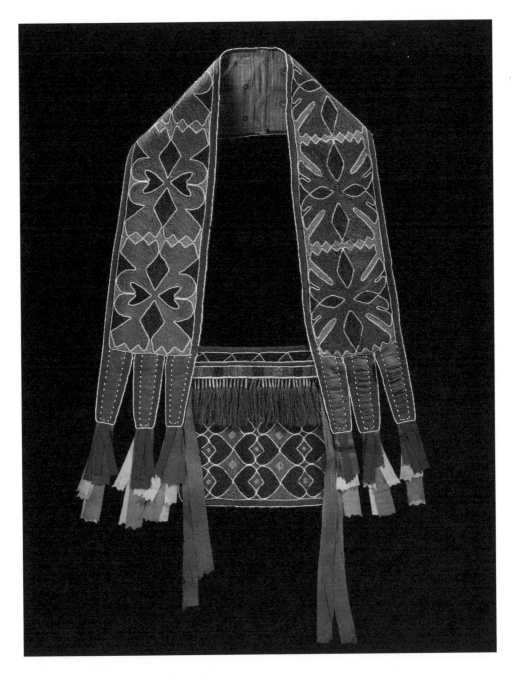

Story Time

SOLO

Imagine that the exhibit nearest to you features prominently in a film or novel. What role does it play in a love story, a thriller, and a sci-fi fantasy?

PARTNERS

Create a story together in which both of you and the exhibit all appear as main characters.

Imagination

#62

Alternative Titles

SOLO

If you don't know the title of an exhibit, give it one. If you already know the title, devise a new one. Be playful, provocative, or plain outrageous. Ensure the title alone will lead to global fame. If necessary, add a short explanatory wall text or audio guide.

PARTNERS

Swap titles between two nearby exhibits. Discuss how their new titles open up original interpretations of the two exhibits.

Imagination

#63

Radical Reframing

SOLO

Instead of engaging with the museum exhibits, consider all those parts of the museum that aren't identified as exhibits, such as a window, a bench, a café, an object label, a power outlet, or a floor tile. Just like dark matter in the universe, non-exhibits occupy most of the museum. Reframe one as an exhibit. What do you choose and how does the act of reframing it as a museum exhibit affect your experience of the object?

PARTNERS

Each of you selects one item you're wearing, or one object, however unspectacular, from your pocket or bag. How would you reframe your partner's object as a museum exhibit and display it to the public?

Imagination

#64

Alchemical Alterations

SOLO

Activate the power of your imagination to mentally morph an exhibit's appearance by changing its color, size, material, and setting.

Which version of the exhibit do you prefer, yours or the original?

PARTNERS

As you both engage with an exhibit, one of you describes how you would imaginatively alter a single element of its appearance. Building on this transformation, the other partner describes a second change. Continue taking turns until you've radically altered the form of the original exhibit and perhaps even its function.

Have you created trash or treasure?

Imagination

#65

Coconut Surprise

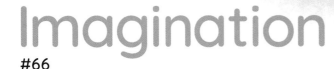

SOLO

If you were to mail a coconut to surprise someone on the other side of the world, what would you place inside it?

PARTNERS

You are storytellers taking turns, one sentence at a time, to recount the adventures of a coconut. This is the first sentence: "I was hanging out with my coconut brothers and sisters on our palm tree in Hawai'i when . . ."

Imagination

#66

Coconut with inscribed address and Seabee decal sent through the mail, 1944.

Brave New World

SOLO

Everything that you now perceive, think, and feel is influenced by all the perceptions, thoughts, and feelings you've ever had. To view the world and its museum exhibits afresh, imagine you're one of the following:

1. A being from another planet seeing earthly shapes and colors for the first time
2. Someone who lived in another historical era, either in the past or the future
3. A newborn seeing the world for the very first time

PARTNERS

From the above list, or from any other radically different perspective, each of you adopts a persona. Through your respective personas, describe to each other what first attracts your attention in the world around you and in a nearby exhibit.

Imagination

#67

Compassion

SOLO

As you engage with an exhibit, realize that soon other people will spend time at this same spot. How might their encounter be different from yours? Wish each future visitor who engages with this exhibit an experience of insight, joy, or reconciliation.

PARTNERS

Identify one exhibit that seems to receive little attention or appreciation. Empathize with the exhibit. Good-cop partner expresses compassion toward the exhibit and asks what extra resources it needs. Bad-cop partner insists that the exhibit needs to get its act together and make some changes.

What curatorial changes would you recommend to increase the exhibit's popularity?

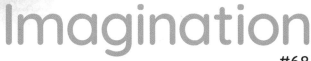

Imagination

Big Bling Theory

SOLO

For the next twenty-four hours, you'll be in possession of one of the most valuable diamonds in the world. What are you going to do with it before you return it to the museum?

PARTNERS

Describe to your partner how possession of the diamond changed your life.

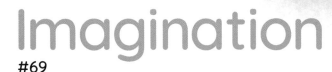

#69

Hope Diamond, the largest of all blue diamonds at 45.52 carats.

Through Other Eyes

SOLO

Discreetly observe another person in the museum, ensuring they don't notice you. Now imagine you can see through that person's eyes. You see what they see. What do you discover when you see the museum through their eyes?

PARTNERS

Partner A imagines they can see through the eyes of Partner B. Remaining in view of Partner A, who stays in place, B moves through the space to curate a visual journey for A.

How does distance affect the power of imagination?

Imagination

#70

Channeling Voices

9

SOLO

Introduce two exhibits to each other. They may know each other well or be talking for the first time, despite the fact they've spent years in the same museum. What do they talk about? What do they say about the museum visitors and staff? Do they get along or do they argue?

PARTNERS

Each of you selects an exhibit and receives the power to voice its thoughts and feelings. Channel your respective exhibits as they finally get to tell each other what's on their mind.

Imagination

#71

Trucker, Trilby, or Toboggan?

SOLO

Abraham Lincoln wore his stovepipe hat on so many public occasions, from campaign stops to battlefield visits, that it became synonymous with the man. After his son Willie died, Lincoln had a black-silk mourning band added to its crown. On the evening in 1865 at Ford's Theatre when Lincoln was assassinated, the hat was by his side. A hat can say a lot about a life.

A museum is planning to put on an exhibition about your life. Which single piece of headwear, real or imaginary, would best represent you?

PARTNERS

Select the headwear for your partner that you feel best captures their personality. Describe it to your partner and explain why you feel this is the perfect fit.

Imagination

#72

Top hat made by J. Y. Davis and worn by Abraham Lincoln, manufacture date unknown.

Museum Miracles

SOLO
Believe it or not, a miraculous event is going to occur within the next thirty seconds. It involves an exhibit and perhaps other people. After thirty seconds, determine what the event was and how it has changed your world.

PARTNERS
One partner selects a nearby exhibit, and the other partner describes the miracle that's going to occur at the stroke of midnight involving this exhibit.

Imagination

#73

A New Acquisition

SOLO

You have an unlimited budget to acquire a new exhibit for the museum. Will it complement and affirm the current exhibits or challenge and disrupt them?

Find an appropriate location to display the new acquisition on a wall, floor, ceiling, or suspended in space. How does the new exhibit impact the existing ones?

PARTNERS

Working as cocurators, you must acquire one new exhibit. The cost of the new exhibit must not exceed ten dollars. What is the new exhibit and what is the justification for acquiring it? How and where will it be displayed?

Imagination

#74

Somewhere over the Rainbow

SOLO

What is the one place and time you long to return to? The magic shoes will take you back. Close your eyes, choose your destination, click your heels three times, and you'll be there in an instant. What's the first thing you'll do after you arrive?

PARTNERS

By clicking your heels against your partner's, the two of you will be transported anywhere in the world. Decide together on your destination, plan your first day there, and then click heels!

Imagination

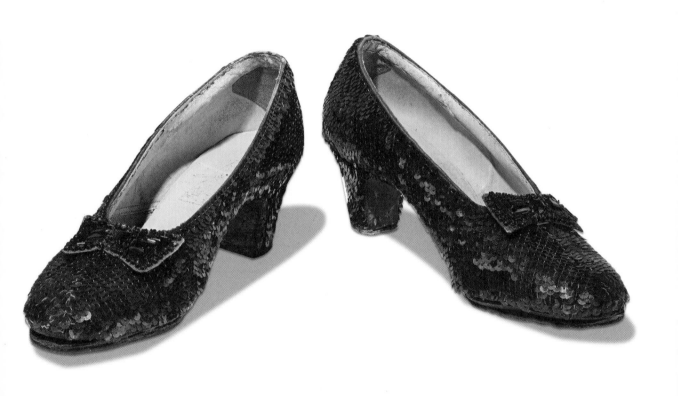

Ruby Slippers worn by Dorothy Gale, as portrayed by Judy Garland, in *The Wizard of Oz*, 1939.

Secret Mission

SOLO

Carefully observe the people around you. One person is on a secret mission. Who is it and what is the mission? What clues can you find in the person's appearance and behavior?

PARTNERS

The titles of the three nearest exhibits will provide the coded instructions for your joint secret mission. Solve the riddle in these cues together and imagine the adventure that you'll share.

Imagination

#76

Security Threat

SOLO

To counter an imminent threat, the museum asks you to find a secret and secure hiding place in your home for one of the current exhibits. The nearest exhibit to you is the one the museum will deliver to your door. After that, the rest is up to you. If you need to dismantle a large object, take care not to damage it.

How does it feel to have a museum exhibit hidden under your roof?

PARTNERS

The museum asks you to test its security system by attempting to remove an exhibit without anyone noticing. Select an exhibit and together develop a foolproof plan to remove it.

You may want to challenge yourselves by targeting a very large exhibit.

Imagination

#77

If These Walls Could Speak

SOLO

Every building has its own character. If the Smithsonian Castle were a person, what kind of person would it be? Imagine the Castle telling you about its life and how it feels to be the center of so much attention.

PARTNERS

If you were a building, what kind of building would you be? Describe it to your partner. What would it look like, what would its function be, and where would it be located?

Imagination

#78

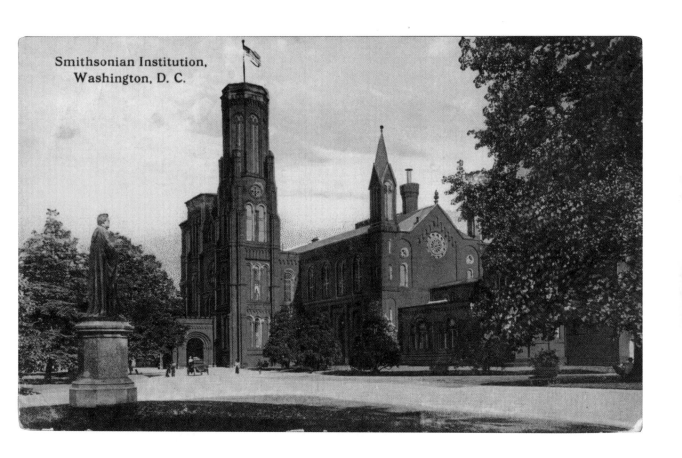

Smithsonian Institution,
Washington, D. C.

Postcard of the Smithsonian Institution Castle, ca. 1907–14.

Immortal v. I'm Mortal

SOLO

Hold your hand up in front of an exhibit. The exhibit will outlive your hand (and the rest of you). Or vice versa. One will have already lived longer than the other. What is the maximum age this exhibit will reach? What will the exhibit and your hand look like when you've reached an advanced age?

How do your responses to these questions affect your experience of the exhibit and of your hand?

PARTNERS

Reflect together on the state of the exhibit and your hands five, fifty, and five hundred years from now.

Imagination

#79

Last Chance

SOLO

Imagine that the next exhibit you look at will be the very last one you'll ever see in your life. Does it evoke appreciation, anger, sadness, or some other response?

PARTNERS

Carefully choose the next exhibit for your partner and explain that due to unforeseen circumstances it will be the very last exhibit your partner will ever see. Give your reasons for selecting this particular exhibit.

Imagination

#80

Action

Action practices empower you to reclaim and reinvent your own experience. Instead of a museum visitor you become a maker, performer, curator, or some combination of all three. Because most of the activities in this section are likely to be visible to others, they also require you to set aside inhibition and unleash the actor within. Break a leg! Not an exhibit.

Bones beneath the Skin

SOLO

Touch your fingers and feel the bones beneath your skin. Touch your head and feel the skull. Sense your entire skeleton. Notice how it morphs into a new shape with each movement you make. If your skeleton were to be exhibited in a museum of natural history (in sixty-five million years or so), how would you like it to be posed?

PARTNERS

Design together and demonstrate a two-person skeletal museum display. The display will be used to educate future generations about contemporary life, so select a suitably representative couple. Video gamers? Politicians? Bargain hunters at a Black Friday sale?

Action

#81

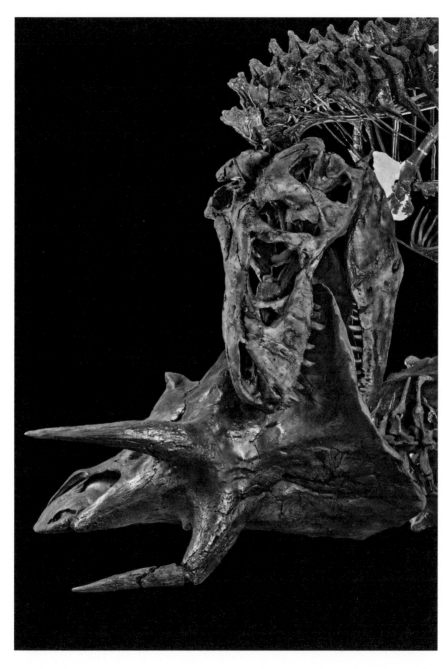

Tyrannosaurus rex looming over a Triceratops horridus.

Very Lifelike

SOLO

In this practice, the exhibit is you. Be the exhibit and allow every visitor, yourself included, to experience it. You don't have to remain motionless or in the same place. You can be a kinetic, mobile exhibit. Where in the space do you exhibit yourself? How do you relate to the existing exhibits? How do you now sense your body? Does your breathing or your sense of weight change? How visible do you make yourself to other visitors? Do they even notice that you are an exhibit?

PARTNERS

You can both choose to become exhibits at the same time, either as parts of a single exhibit or as two separate ones. Alternatively, one of you may choose to become an exhibit while the other remains an observer. The roles can be swapped at any time, so it's possible that you may not be aware of your partner's current role. Can you guess whether your partner is an exhibit or a visitor?

Action

#82

Imposing Posing

SOLO

Turn yourself into a sculpture that mirrors an exhibit. Find a pose that captures its essential qualities and hold the pose for at least one minute. What sensations do you feel in your body? What emotions arise?

How does this pose enrich your understanding of the exhibit?

PARTNERS

Partner A secretly selects a nearby exhibit and becomes a sculpture that mirrors it. Can Partner B guess the exhibit from the pose? After correctly identifying the exhibit, cocreate at least three more human sculptures that represent the same exhibit. What different aspects of the exhibit does each sculpture highlight?

Action

#83

Fancy Footwork

SOLO

It's remarkable. Your feet (almost) always agree whether to rest or move, and which direction to move in. Imagine if those feet disagreed, one wanting to go forward and the other backward. What if one foot is very light and ready to run, while the other is heavy and fixed to the ground? What would happen if one foot wants to be close to its mate and the other tries to keep as far away as possible?

PARTNERS

Your objective is to touch your partner's right foot with either of your feet while avoiding your partner's attempts to do the same thing. The first person to make contact three times wins.

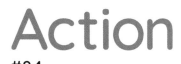

Action

#84

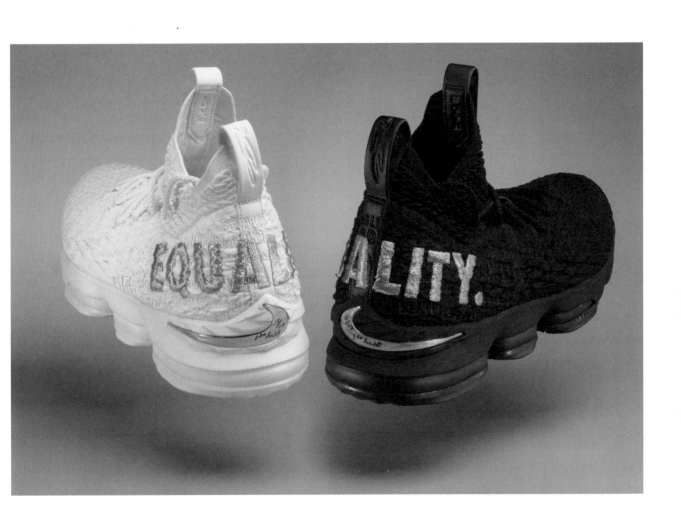

Nike "Equality" basketball shoes worn by LeBron James, 2017.

The Gentlest Touch

SOLO

Although we're generally not allowed to touch exhibits, we can always do so in our imagination. Positioned well beyond arm's reach of an exhibit, extend your hand(s) toward it so your fingers appear to make contact. Will you caress it, pinch it, tickle it, smack it, or gently place a hand on it? Which hand motions does the exhibit invite?

How does the exhibit respond to your touch?

PARTNERS

Observe an exhibit together and decide what kind of touch it needs. Do you scratch it, stroke it, or give it a four-hand massage? After you've finished with the exhibit, give each other the same no-touch treatment. Take turns or administer the treatment to each other at the same time.

Action

#85

Action!

SOLO

Like a video camera lens, your eyes remain immobile in their sockets. You can only shift your gaze by moving your body. Your head is fixed in position and does not tilt or turn. To tilt the camera up and down, move your torso and head from the hips. To pan the camera, rotate your feet or move your whole body sideways. To zoom in, approach your subject. Rehearse the camera moves for a one-take twenty-second video to present an exhibit on the museum's website.

Notice how difficult it is to stop your eyes from advancing of their own accord, independently of your head and body.

PARTNERS

In this practice, your head and body remain fixed, but your eyes can swivel. Position yourselves back-to-back, side on to an exhibit. With your heads and bodies always facing straight ahead in opposite directions, look at the exhibit out of the corner of your eyes. Collaborate to give each other a complete description of the exhibit.

Inked

SOLO

Tattoo the image of an exhibit onto your body. First select a desirable exhibit or part of an exhibit, and then carefully choose the body part on which you'll apply the tattoo. Your fingertip is the needle and your skin is the tattoo surface. Will the tattoo be prominent or hidden from view? How big will the tattoo be? Very large or microscopically small? Will it be composed only of lines or include shading and colors?

PARTNERS

In the presence of a number of different exhibits, Partner A stands behind Partner B and uses a fingertip to "tattoo" the outline of one of the exhibits, or a part of an exhibit, onto Partner B's back.

Can Partner B guess which exhibit has been tattooed onto their back?

Action
#87

Prosthetic Pencil

SOLO

Attach an imaginary pencil to a body part, such as your nose or elbow, and then move the body part to trace the outline of the exhibit. You can also use your pencil to add details and shading. Notice how different distances from the exhibit affect the size of your movements.

Compare the experience of sketching the exhibit with different body parts, such as your knee, belly button, or big toe.

PARTNERS

Challenge each other to make a sketch of an exhibit after you attach an invisible pencil to your partner's body. Be creative in the body part you select. If the task is too easy for them, attach the pencil to a more demanding body part. Take turns at sketching an exhibit or sketch at the same time. Don't forget to sign and date your work.

Action

#88

Above the Clouds

SOLO

Close your eyes and deepen your breathing. Feel how with each inhaled breath you become lighter, and with each exhaled breath, you let go of unnecessary baggage. Spread your arms and begin to feel yourself hovering above the ground. At first, you may only be able to remain a few inches above the ground, but with practice, you can reach the stars. Fly through the museum for at least twelve seconds.

PARTNERS

Hook arms with your partner and extend your free arms to create wings. Decide who the pilot is, then synchronize your breathing, roll down the runway, and take off. Pull back on the joystick and soar above the clouds. Once you're up there, bank your wings to make lazy circles in the sky. If you're feeling adventurous, try some aerobatics. Take turns piloting the plane.

Action

#89

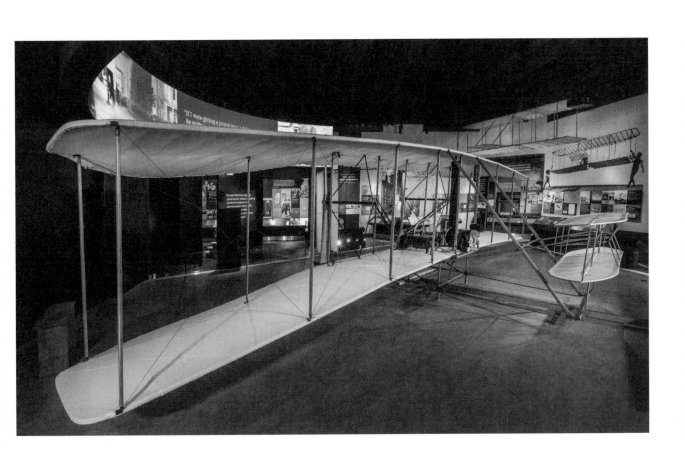

1903 Wright Flyer created by Orville and Wilbur Wright.

Click, Click

SOLO

Identify an isolated corner, niche, or spot where few visitors would be likely to pause to view exhibits. You're now a camera on a tripod. Carefully adjust your position to compose a compelling image of an exhibit from this unusual perspective. When you're satisfied with the composition, wait for the right moment and capture the view in memory.

What title would you give the photograph?

PARTNERS

Partner A is a camera. Partner A closes their eyes and is guided by Partner B, the photographer, who carefully positions A in front of an exhibit. When Partner B is satisfied with the composition, B taps A on the shoulder. Just like the shutter of an actual camera, Partner A opens and closes their eyes. (Exposure time shouldn't be longer than one second.) The photographer should compose some unexpected and intriguing images. Swap roles and repeat.

What will be the title of your joint photographic exhibition?

Action

#90

Museum Moves

SOLO

Dance with an exhibit. Which kind of movements does it inspire: rigid robot moves or flowing organic gestures? Take your lead from the exhibit. Your movements may be very subtle or highly expressive. How daring will your dance become?

PARTNERS

Choose an exhibit that inspires the two of you to dance. You each now have two dancing partners: one is human and the other is the exhibit. Let the dance begin! Can each of you ensure that both of your dancing partners receive equal attention?

Action

#91

Dance of the Tiger

SOLO

If the sleeping tiger of fear awakens, it gnaws at our being and could even devour us.

Who or what do you fear most at this point in your life? Name this fear and visualize it being represented by one of your thumbs. Take a deep breath and, using your other hand, gently wrap your fearful thumb with fingers of compassion. Continue taking slow deep breaths as you now firmly grasp your thumb with fingers of courage.

How many breaths does it take until the fear begins to dissolve?

PARTNERS

Partner A is a ravenous tiger. Partner B is their human prey. Partner A stalks Partner B, waiting for the right moment to pounce. Partner B can choose to freeze, fight, flee—or embrace the tiger. Both tiger and human must play their roles in super slow motion.

Action

#92

Jaguar mask made by Nahua people of Guerrero, Mexico, ca. 1950.

Hummingbirds

SOLO

Hum your response to an exhibit. Mirror the exhibit's qualities and character by finding the pitch, length, and volume that best suit it. The exhibit might invite a simple tune or more complex melody. Which qualities of the exhibit inspire your humming? Is it the color, form, material, or other properties? How does your humming correlate with your eye movements?

PARTNERS

Honor the exhibit by humming an improvised duet for at least one minute. Can you maintain equal awareness of your humming, your partner's humming, and the exhibit? Place one hand on your throat and one on your partner's throat or chest to feel the vibrations as you both hum.

Action

#93

New Connections

SOLO

Approach another visitor and show them the following:

Would you like to explore an exhibit with the person showing you this message? The book you're looking at is called *Mindful Eye, Playful Eye* and contains 101 amazing museum activities. If you're curious to try one of these activities, turn to a random page in the book and follow the instructions with your new acquaintance.

PARTNERS

Pretend to be strangers who find themselves in front of the same exhibit. You know nothing about each other but are both keen to make contact. Who will make the first approach?

Involve this "stranger" in a conversation about the exhibit. If you're feeling more playful, approach another pair of visitors and show them the invitation in the SOLO practice.

Action

#94

Hot Horn

SOLO

The maestro's trumpet hasn't been played in decades. It's been silent for so long it doesn't remember what it sounds like. To approximate the original with your personal air trumpet, softly whisper a phrase like "dah-doo, dah-doo" through a very small gap in your lips. Repeat the phrase, this time voicing it and gradually raising the pitch. Make sure to project the sound to the front of your mouth. For variety, add another phrase, such as "dat-dadda-dadda-dat-da." Now take it away!

PARTNERS

Jam together. One of you plays the air trumpet following the SOLO instructions, and the other sings along or plays another instrument. Switch roles for the second verse.

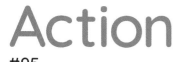

Action

#95

Louis Armstrong trumpet made by Selmer Instrument Company, 1946.

Speed Dating

SOLO

Encounter as many exhibits as you can while holding your breath. You may need to rapidly scan your visual field, or, if it's safe, move quickly from one room to another. Afterward, close your eyes and try to recall all the exhibits you've encountered. Does this practice remind you of anything you do every day?

PARTNERS

Separately, follow the SOLO instructions while competing to encounter a higher number of exhibits.

As you recall the exhibits, identify the one that's most memorable for each of you. Return together to the two exhibits and discuss what made them stand out.

Action

#96

Vertical Sweep

Facing an exhibit, let your head and arms hang down, palms toward each other. Look between your hands toward the ground. Keeping your gaze focused on what is framed by your hands, slowly raise your outstretched arms until they reach the space above your head. When your hands are above your head, pause for a moment and then reverse the process, slowly lowering your hands until your head and arms are hanging down again.

How does your experience of the exhibit differ on the upward and downward arcs?

PARTNERS

Partner A crouches down, positioning their hands, palms inward, on each side of Partner B's feet. Partner A slowly glides their hands along the sides of B's body without making contact, creating an imaginary outline around Partner B. Partner A's goal is to keep their hands as close as possible to Partner B until they meet above B's head. If Partner A accidentally brushes against B's body or clothing, A must start again from B's feet. If this is too easy, Partner B can gently sway from side to side or strike a more challenging pose.

Action

Butterfly Dreams

SOLO

Like a caterpillar that cocoons itself and then emerges as a butterfly, you go to bed a human and awake the next morning as a butterfly. After a lifetime of earthbound crawling, what must it feel like to open your wings and fly? Try it for yourself. Come out of your cocoon and give in to the irresistible urge to flutter.

Most butterflies live for less than a month, so make the most of the next three or four weeks. What exactly do you plan to do?

PARTNERS

You have both just awakened as butterflies, ready to take wing. But then you suddenly wonder, are you humans dreaming that you're butterflies, or are you butterflies dreaming that you're humans pretending to be butterflies? Perch together to discuss this conundrum. Make sure you both adopt the typical butterfly perching pose with wings pressed together above your back. After you've resolved the question, take your first flight together.

Action

#98

Butterfly resting on a flower in the indoor Butterfly Pavilion at the Smithsonian's National Museum of Natural History, 2008.

Unsurveilled

SOLO

Look around you. Who's watching you? If you knew that your every move was being closely scrutinized by a very critical observer, how would it change the way you engage with an exhibit? Conversely, how would you behave differently if you knew your best friend was watching you through surveillance cameras at this very moment? They are. Act accordingly.

PARTNERS

These days, most museums have security cameras surveilling every space—whether you can see them or not. Together, perform a fifteen-second sequence that will bring a smile to the face of the person viewing the live feed.

Action

#99

The Gift

SOLO
At the end of your visit, close your eyes and try to remember all the exhibits you've encountered. Which one will you revisit before leaving the museum? What parting feelings and thoughts will you share with it?

PARTNERS
Among all the practices you've explored today, which did you find the most engaging and why? Express your mutual appreciation by looking into each other's eyes and sharing a silent smile.

Finding Wonder Everywhere

SOLO

When you leave the museum, your mindful, playful eye doesn't need to close. You can extend the same attention, curiosity, sense of wonder, and power of imagination to everything around you. What's the first thing you see outside the museum that you would display in an exhibition?

PARTNERS

To end your session together, consider this: the world outside the museum is in fact a curated exhibition. Challenge each other to find the evidence.

The adventure continues!

Action

#101

Acknowledgments

Creating this book was an amazing adventure, involving travels, real and virtual, across four continents and the support of many remarkable people.

We'd like to acknowledge some of them here, starting with our allies at Smithsonian Books: director Carolyn Gleason, who endorsed the initial proposal and believed in the value of this project; senior editor Jaime Schwender, who shared her personal enthusiasm for the manuscript and assisted us tremendously with her committed spirit and professional skills; eagle-eyed editor Sharon Silva; and marketing director Matt Litts and promotions specialist Sarah Fannon for enabling our vision to reach readers and museum visitors around the world. Bravo also to our designer, Daisuke Yajima, in Tokyo for so empathically giving expression to this vision and to Brian Barth for his sensitive typesetting.

As we wrote and trialed the 101 practices, we received support, advice, and encouragement from other remarkable people, including Tamsin Cull, head of public engagement at the Queensland Art Gallery | Gallery of Modern Art in Brisbane, who recognized the value of our approach; Chase Robinson, director, and Lori Duggan-Gold, deputy director, of the Smithsonian's National Museum of Asian Art, who supported the project and helped make it possible; Soheil Ashrafi, associate dean and chair of communications and media at the School of Arts and Sciences, University of Central Asia, who enabled us to carry out and publish joint research on the Playful Eye in Kyrgyzstan; and Elliot Kai-Kee and Lilit Sadoyan from the J. Paul Getty Museum, with whom we delivered a series of workshops and enjoyed many enriching conversations.

Special thanks to Jooyeon Park from the *Red Onion Randy* podcast, whose insightful critiques of the practices and keen sense of the playful made invaluable contributions to the development of the manuscript.

We're also grateful to the many friends, colleagues, students, and museum staff and visitors who contributed to the development of the Playful Eye project: Rhonda Schaller, Pratt Institute, Brooklyn, New York; Eric Bruehl, J. Paul Getty Museum, Los Angeles; Julia Rust, Olbricht Foundation, Berlin; Katie Russell and Frances Wild, National Gallery of Australia, Canberra; Michaela-Sophie Chin, Queensland Art Gallery | Gallery of Modern Art, Brisbane; Altyn Kapalova, Cultural Heritage and Humanities Unit, University of Central Asia, Bishkek; Altynai Kudaibergenova, Gapar Aitiev Kyrgyz National Museum of Fine Arts, Bishkek; Baktygul Midinova and Anatoly Tsibuch, Osh Regional Museum of Fine Arts, Osh; Urbaeva Siyagul Urkasymovna, Dobolu Museum, Naryn Oblast; Katherine Bond, Scott East, Edward Scheer, and Bronwen Williams, UNSW Sydney School of Art & Design; and José da Silva and Catherine Woolley, UNSW Sydney Galleries.

We'd like to acknowledge the generous financial support for book design development provided by the University of New South Wales Faculty of Arts, Design & Architecture Research Output Scheme.

It's been an immense privilege to have been able to dedicate our energies to a passion project that was conceived with the hope of contributing to a more playful and conscious world.

Extended Image Captions and Credits

7. *Discovery* was the third space shuttle orbiter vehicle to fly in space. It entered service in 1984 and was retired in 2011, after completing its thirty-ninth mission.

Smithsonian Air and Space Museum, photo by Dane Penland (NASM2020-01907)

13. This reclining rocking chair of bent beechwood and woven caning exemplifies the fusion of form and function. It was made by the Udinese-based firm Società Anonima Antonio Volpe around 1905.

Cooper Hewitt, Smithsonian Design Museum, museum purchase from the Members' Acquisitions Fund of Cooper Hewitt, National Design Museum, 2007-7-1-a/c, photo by Matt Flynn © Smithsonian Institution

17. This bronze lion is one of a pair (one roaring, one sleeping) that stand guard at the Connecticut Avenue entrance of the Smithsonian's National Zoo & Conservation Biology Institute. They are copies of a pair of concrete lions on the William Taft Memorial Bridge designed by Roland Hinton Perry and originally installed in 1906.

The George F. Landegger Collection of District of Columbia Photographs in Carol M. Highsmith's America, Library of Congress, Prints and Photographs Division

21. In this sculpture from Batoul S'Himi's series *World Under Pressure*, the artist's selection of a pressure cooker takes a typical domestic space, the kitchen, and places it within a global picture in order to draw attention to the underwhelming representation of women and women's issues. It also alludes to the mounting pressure for change.

© 2011 Batoul S'Himi, National Museum of African Art, Smithsonian Institution, museum purchase, 2014-15-1, photo by Franko Khoury

23. One of a set of twelve plates manufactured by the Chelsea Porcelain Manufactory in England between 1745 and 1784. The style is named after Sir Hans Sloane

(1660–1713), a physician to Queen Anne who was also a botanist and plant collector.

Cooper Hewitt, Smithsonian Design Museum, Gift of Irwin Untermyer, ca. 1757–69

27. One of a pair of guardian figures, each over seven feet tall. This warrior once kept watch over the Buddha and his followers outside a temple in Nara, Japan, in the mid-thirteenth century.

National Museum of Asian Art, Smithsonian Institution, Freer Collection, Purchase—Charles Lang Freer Endowment, F1949.21

35. This 1977 chromogenic print depicts Ana Mendieta's *Anima (Alma/Soul)*, 1976, in which the artist used fireworks to set wooden effigies of her outline ablaze in a clearing in Oaxaca, Mexico. The flames lit up the night sky, asserting her presence and power before the figures collapsed into a pile of ash.

© 1976, Estate of Ana Mendieta, museum purchase through the Smithsonian Latino Initiatives Pool and the Smithsonian Institution Collections Acquisition Program. Ana Mendieta, Detail: *Anima (Alma/Soul)*, 1976. Suite of five color photographs. Courtesy of Galerie Lelong & Co., Licensed by Artists Rights Society (ARS), New York

39. This portrait for a carte de visite is the earliest known image of American abolitionist Harriet Tubman (1822–1913), taken when she was in her mid-forties. In the 1850s, she guided dozens of enslaved people to freedom using the network of safe houses known as the Underground Railroad, and during the Civil War, she served as a scout, nurse, and spy for the Union army.

Collection of the National Museum of African American History and Culture shared with the Library of Congress

43. Emma Russell (1909–2004) was a fifth-generation African American quilter who grew up quilting in the Doloroso community of Woodville, Mississippi. Along

with her sister, mother, and other family members, she played a pivotal role in documenting African American quilting traditions, first in the Mississippi Delta and then nationally.

49. The most celebrated American landscape artist of his time, self-taught Ralph Albert Blakelock (1847–1919) paved the way for American Modernism when he stopped painting in a realistic style and began depicting the environment through expressive, thick paint strokes and a dark, brooding palette. During much of his career, he painted nocturnal landscapes, such as *The Three Trees*, that employed an evocative use of light to portray not only a place but also an emotion or state of mind.

53. Known for his monumental Latinx sculptures in shiny, colorful fiberglass, Luis Jiménez (1940–2006) intentionally titled one of his most famous works *Vaquero*, which means "cowboy" in Spanish, to emphasize the Spanish and Mexican roots of this American icon.

55. On New Year's Eve 1879, Thomas Edison used this carbon-filament bulb in the first public demonstration of a practical electric incandescent lamp.

61. Nam June Paik (1932–2006) hailed as the father of video art, is credited with originating the term *electronic superhighway* in the 1970s. This sculpture is made up of 336 televisions, 50 DVD players, 3,750 feet of cable, and 575 feet of multicolored neon tubing.

65. Relatively unrecognized during his lifetime, American-born painter Louis Eilshemius (1864–1941) is best known for his figurative and landscape paintings. Although he started off working in an academic style with early influences from the French Barbizon School, by 1910, he had turned to more expressionistic nocturnal depictions of life in New York City. In *East Side, New York*, Eilshemius captures the fleeting ambience of the city at night through his use of colors and control of light and shadows.

69. This tranquil and engaging view of Mount Fuji was one of hundreds produced by painter and printmaker Katsushika Hokusai (1760–1849) during his lifetime. Here, at the age of nearly eighty, the artist gives visual form to his quest for long life by portraying a young boy in the thrall of the immortal mountain.

73. At first it was a dining room in the London mansion of a shipping magnate, designed to showcase his collection of Chinese porcelain. In 1876–77, the artist James Abbott McNeill Whistler completely redecorated the room as a "harmony in blue and gold." In 1892, the room was purchased in its entirety by Charles Lang Freer, who had it installed in his Detroit, Michigan, home. Later it was moved to the Freer Gallery of Art, which he founded in 1923, and where it has been on permanent display ever since.

77. In this painting by French artist Edgar Degas (1834–1917) the American painter Mary Cassatt (1844–1926) is holding a group of photographs as if in the midst of discussing them with Degas.

National Portrait Gallery, Smithsonian Institution; Gift of the Morris and Gwendolyn Cafritz Foundation and the Regents' Major Acquisitions Fund, Smithsonian Institution

81. In 1974, metal sculptor Albert Paley won the national competition to design decorative doors for the Renwick Gallery shop. A masterpiece of ironwork, his *Portal Gates* of steel, bronze, copper, and brass rapidly became an icon for the museum.

Smithsonian American Art Museum, commissioned for the Renwick Gallery, 1975.117.1A-B

87. Traditional Native American clothing did not have pockets, so almost everyone carried a bag of some kind. Bags like this were called bandolier bags because the straps worn across the body—from one shoulder to the opposite hip—resembled bandoliers worn by military men to carry ammunition. Heavily beaded bandolier bags might take a year to complete and were important status symbols.

National Museum of the American Indian, 21/3358, photo by Walter Larrimore

93. In 1944, this coconut was mailed by Raymond J. Boudet, a navy Seabee stationed in Hawai'i, to his wife, Marie Boudet, in Springfield, Massachusetts. Their addresses are carved into the shell, and the back of the coconut bears a heart pierced with an arrow in which are carved "Ray" and "Marie." Stamps with a value totaling thirty-seven cents are affixed to a cardboard tag.

National Postal Museum, Smithsonian Institution

97. Extracted from a mine in eastern India in the seventeenth century, the Hope Diamond passed through the hands of many owners, among them Louis XIV of France and Henry Philip Hope, a member of the Dutch Hope banking family, for which the famous blue stone is named.

Department of Mineral Sciences, National Museum of Natural History, Smithsonian Institution, G3551, photo by Dane Penland

101. After President Lincoln's assassination at Ford's Theatre, the War Department preserved his hat and other materials left at the theater. With permission from his wife, Mary Lincoln, the department gave the hat to the Patent Office, which, in 1867, transferred it to the Smithsonian Institution.

National Museum of American History, transferred from the War Department with permission from Mary Lincoln, 1867

105. Several pairs of Ruby Slippers were made for Judy Garland to wear during the filming of *The Wizard of Oz*. These slippers are a mismatched pair, indicated by the use of different base shoes and markings that read "#1 Judy Garland" on the right shoe and "#6 Judy Garland" on the left.

National Museum of American History, THE WIZARD OF OZ and all related characters and elements © & ™ Turner Entertainment Co.

109. The Smithsonian Institution Building, popularly known as the Castle, is the signature building of the Smithsonian Institution. Completed in 1855 in the Norman style, today it houses the institution's administrative offices and the Smithsonian Information Center. Located inside the north entrance is the crypt of James Smithson, the founding donor of the Smithsonian.

Courtesy of Smithsonian Institution Archives

115. *Tyrannosaurus rex*, the King of the Tyrant Lizards, and *Triceratops horridus*, one of the largest and most recognizable of all dinosaurs, lived sixty-eight to sixty-six million years ago during the Late Cretaceous period in what is now the western United States.

Tyrannosaurus rex, USNM 555000, Courtesy of the US Army Corps of Engineers, Omaha District, and Museum of the Rockies, Montana State University; *Triceratops horridus* (composite cast), Smithsonian Institution; photo courtesy of Smithsonian Institution

119. LeBron James wore this pair of "Equality" shoes during the first half of the game between the Cleveland Cavaliers and the Washington Wizards on December 18, 2017. James finished with 20 points, 15 assists, and 12 rebounds, helping the Cavaliers beat the Wizards 106 to 99.

Collection of the Smithsonian National Museum of African American History and Culture, Gift of LeBron James, © Nike

125. On December 17, 1903, the Wright brothers inaugurated the aerial age with their successful first flights of a heavier-than-air flying machine at Kitty Hawk, North Carolina. On its twelve-second first flight, the airplane traveled 120 feet.

Smithsonian National Air and Space Museum, photo by Jim Preston (NASM2022-05714)

129. This wooden mask is carved to represent the head of a jaguar, which is called *el tigre* in Spanish, and its design is typical of the tigre masks from Guerrero, Mexico. These masks were worn during the Dance of the Tiger, which was performed to protect crops, field workers, and domestic animals from predators. During the dance, the tigre is chased and eventually caught and killed.

National Museum of the American Indian, 24/5926, Gift of Richard H. White

133. In February 1946, Joe Glaser, Louis Armstrong's manager and close friend, wrote to Selmer Instrument Company and asked for a new trumpet custom-made for Armstrong's use. Selmer agreed and presented him with this personally inscribed Selmer B-flat trumpet, which was made only for Armstrong and never mass-produced.

Collection of the Smithsonian National Museum of African American History and Culture

137. The eleven-thousand-square-foot Butterfly Pavilion within the Smithsonian's National Museum of Natural History is a climate-controlled environment that is home to hundreds of butterflies and tropical plants. Visitors are able to witness the life cycle of butterflies, which typically lasts only three to four weeks, by walking freely through the pavilion.

Photo by James Di Loreto, Smithsonian Institution